Contents

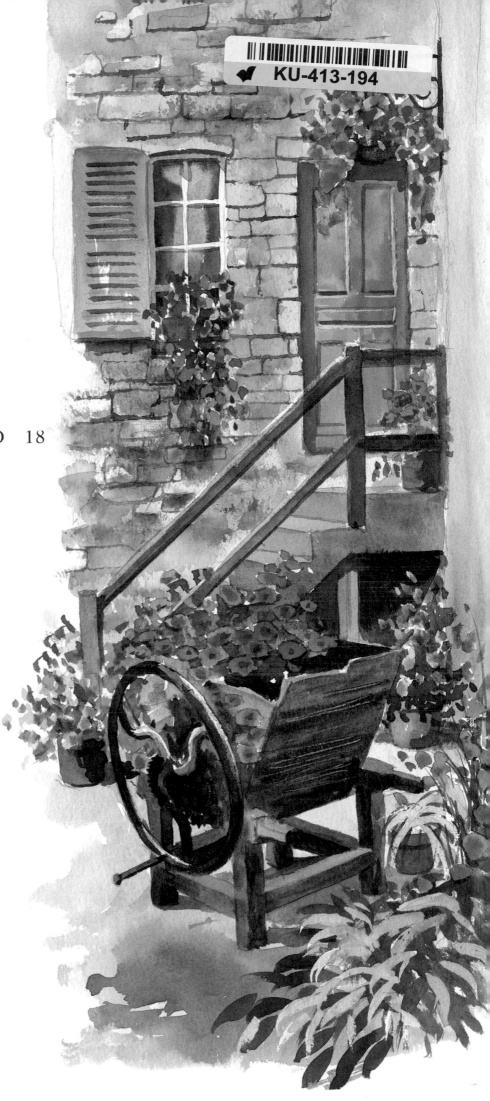

Introduction

I love painting flowers and hopefully I can share some of the hints and tips for painting them with you. That said, I'm an artist, not a botanist; and this book is in no way a botanical reference book. Rather, it is intended to show how you can use some fairly standard and also some more unusual techniques to add flowers to your watercolours. After all, you don't need to be a gardener to paint a good picture!

When doing painting demonstrations or workshops, I often jokingly tell my students that if a painting is going horribly wrong, they can rescue it by simply adding bluebells or poppies! While bluebells and poppies are obviously not always appropriate, the idea is that by using a prop such as flowers in a painting, you can not only improve the overall look of it but also make the finished painting look more eye-catching.

For example, a lot of my paintings use a footpath as a way of leading people into a painting. Used on its own, a footpath can be a little uninspiring; but by dressing up the scene with poppies, the whole character of the painting is changed.

When I first started painting, I found winter scenes more appealing to paint because of the somewhat limited palette, and I would rely on different weather conditions and wintry moods to give the composition its main theme. I found summer landscapes, with their dominant colours leaning towards greens, much more restrictive until I found that simply by adding some flowers to the foreground, I could change the whole thrust of the painting, bringing colour and life to an otherwise ordinary scene.

Looking back at many of my paintings, I am surprised to see how much floral detail I have used in a variety of different types of scene, such as landscapes, townscapes and river scenes; and some typical Terry Harrison-style examples of these are covered on the following pages. I hope this book is of some help in adding a little splash of colour into your artwork.

Terry Harrison

Heart of the Village
480 x 600mm (18¾ x 23½in)
This idyllic country village, and its key elements of thatched cottages, a pub and church are linked together with splashes of floral colour.

Terry Harrison's
Watercolour Flowers
in the Landscape

SEARCH PRESS

First published in Great Britain 2006

Search Press Limited
Wellwood, North Farm Road,
Tunbridge Wells, Kent TN2 3DR

Reprinted 2007, 2008, 2009

Text copyright © Terry Harrison 2006

Photographs by Roddy Paine Photographic Studios
Photographs and design copyright © Search Press Ltd. 2006

ISBN 978-1-84448-097-5

The Publishers and author can accept no responsibility for any
consequences arising from the information, advice or instructions given
in this publication.

Suppliers
If you have any difficulty obtaining any of the materials and equipment
mentioned in this book, please contact

Terry Harrison at:

Telephone: +44 (0)1386 584840

Website: www.terryharrisonart.com

Publishers' note
All the step-by-step photographs in this book feature the author,
Terry Harrison, demonstrating how to paint with watercolours. No
models have been used.

Printed in Malaysia by Times Offset (M) Sdn Bhd.

Dedication
To my wife Kate and my two
daughters Amy and Lucy.

Acknowledgements
*I'd like to thank my long-suffering wife Kate for her
patience and support in the running of my ever-
growing projects, as well as her brother
Derek Whitcher and sister Judy Whitcher, all of whom
make sure the wheels of my business stay on, despite
my best efforts to make them fall off!
Thanks also to Daniel Conway, my framer, assistant
and friend; a loyal, extremely helpful and much-valued
member of my staff.
Without the assistance of my helpers, I would be
unable to cope with doing the art and craft shows up
and down the country, so my thanks and gratitude go
to each and every one of these wonderful ladies.
Thanks to Edd (the editor) Ralph, for being patient
and understanding, knowing my limitations and also
getting the jokes.*

Cover
Summer Colours
350 x 500mm (13½ x 19½in)
In this painting the flowers are used as a way of leading you into
the picture. Simply have the larger flowers in the foreground and
smaller ones in the background to form a sweeping 'S' shape
across the painting.

Page 1
A Cotswold Cottage
320 x 380mm (12½ x 14¾in)
This cottage is obviously owned by a keen gardener with plenty of
time on their hands to create this typical 'chocolate-box' scene.

Page 3
The Winepress
180 x 470mm (7 x 18¼in)
There are many ways of displaying potted plants. This creatively-
used old winepress shows off an impressive display of flowers and
forms a centrepiece for this quiet corner of a French courtyard.

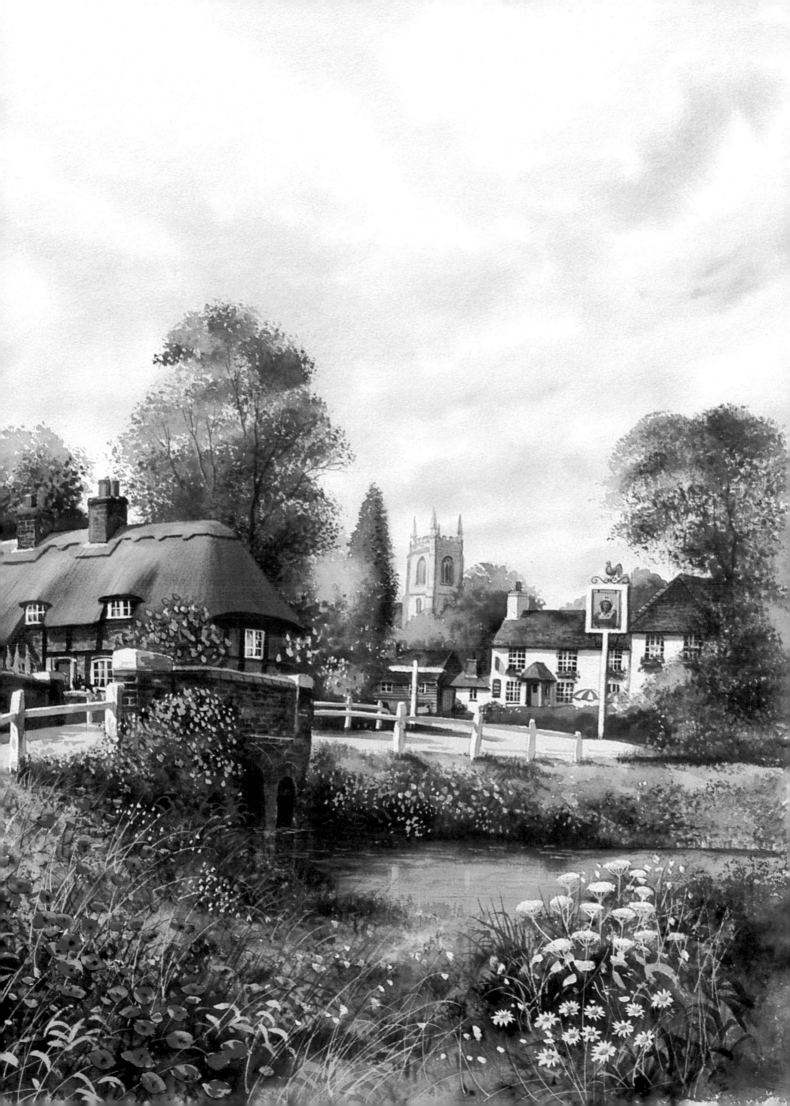

Materials

I always use a fairly restricted range of art materials, with many of the brushes being my own design, and the colours based on a thirteen-colour palette. For this book on painting flowers, I have extended that palette with three more exotic colours to spice up the paintings.

Brushes

On the face of it, there is quite a wide selection of different brushes; but each one is designed to produce its own unique brushstroke, ranging from large wash brushes to very fine detail brushes; and even brushes that paint texture. Pages 14–16 explain how to use each brush in turn.

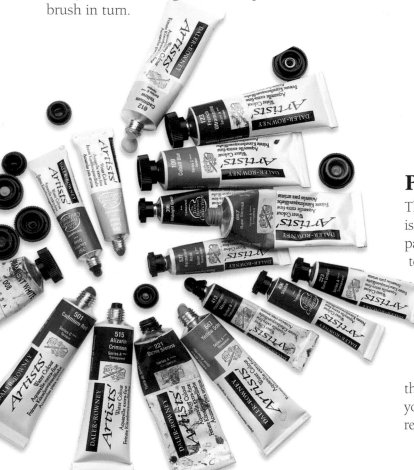

Paints

The range of colours that I use is fairly standard; but it is worth noting that I always choose tube colours over pans. The reason for this is that you are always told to use large brushes, and it is extremely difficult to use these with a standard half-pan palette. Tube colours are a better option for using larger brushes because you can put them on to a larger format palette such as a traditional palette, a plastic one, or even a dinner plate!

When learning to paint, you should always use the best quality paint available to give you all the help you can get. As a professional artist, I would always recommend artists' quality paints over students' quality.

Papers

It would appear that every professional artist has their own choice of paper, and this is often based on whatever he or she started painting on, or what their tutor told them to use.

Throughout this book, I have used 300gsm (140lb) rough-surfaced paper, but there is no harm at all in experimenting with different types of paper. You might find that there is a kind that is exactly right for you. The reason that I like this weight of paper is that it is neither too absorbent nor too water-resistant. It is also an ideal surface for using masking fluid.

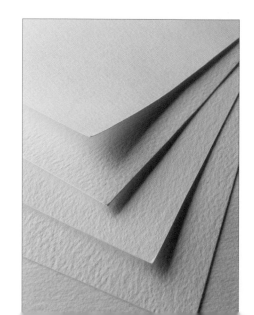

Other materials

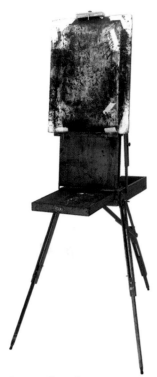

Easel
This is a box easel (it all folds down into a neat carrying box). It has a pull-out tray which is an ideal shelf for the palette. The easel itself is fully adjustable to any angle and the legs can be extended so that you can paint standing up or outside; or they can be folded away and the easel rested on a table to paint sitting down indoors.

Bucket
My famous bucket, star of many videos and books. The simple reason for using a bucket or large water container is to ensure you can easily wash out the paint from your brushes and also to keep the water in your painting as clean as possible.

Masking fluid
Masking fluid is a liquid latex which is used to protect your paper from the watercolour. This is sometimes called resist, and I use it extensively when painting flowers to ensure that I get a fresh colour on a white background.

Masking fluid brush
This is simply an inexpensive nylon brush used to apply masking fluid to a painting. You can substitute an old brush for this job if you prefer.

Masking tape
Masking tape secures your watercolour paper to a drawing board, and also can be used as a mask and a border for a painting. When you finish your painting, remove the tape to reveal a sharp edge.

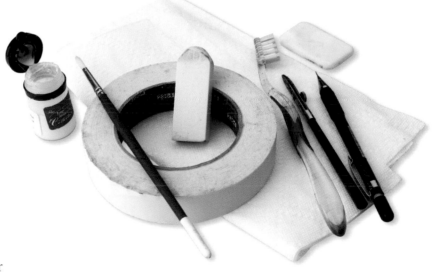

Eraser
If anyone asks you what you use an eraser for in your paintings, always reply 'enhancing' rather than 'correcting'!

Toothbrush
This is used with masking fluid when using the spattering technique.

Soap
The soap is used to protect your brushes when applying masking fluid.

Ruling pen
A ruling pen can be used for applying masking fluid and also watercolour and gouache. In this book, it is used for long grasses and flower stems.

Propelling pencil
This is ideal for fine drawing, eliminating the need to keep on sharpening a normal pencil.

Kitchen paper
Kitchen paper is used not only for mopping up spills, but also for removing excess paint from your brush if you overload it.

My palette

There are so many colours available to the artist these days, it can be very confusing choosing a selection to use. As you paint, you will get used to using a certain range of colours, so if you restrict yourself to the colours that you find you use the most, you will eventually learn to get consistency in your painting style.

With this in mind, don't be afraid to extend your palette; some things require a specific colour. For example, permanent rose is a great colour for painting fuchsias, but is very difficult to mix from a limited palette.

Tip

You can add watercolour to white gouache to produce solid, opaque colours. This is useful for painting additional flowers over dark areas.

Colours I use

burnt umber raw sienna burnt sienna

ultramarine cobalt blue permanent mauve

In a starting palette, you need a good range of earth colours; I use burnt umber, raw sienna and burnt sienna, but you could also add yellow ochre.

You also need a warm and a cool blue. Ultramarine and cobalt blue respectively are ideal. Permanent mauve is a blue-violet which is used for petunias, and is an excellent addition to your colour range.

cadmium red alizarin crimson permanent rose permanent magenta

shadow

The first red I have on my palette is cadmium red, which is neither too blue nor too yellow, and so will not become muddy when mixed with other colours. The other red I use is alizarin crimson which is ideal for mixing with blues to create a whole range of purple hues. Permanent rose and permanent magenta are good alternative reds.

This mix of cobalt blue, alizarin crimson and a touch of burnt sienna gives a subtle purple shade which is ideal for painting shadows. The manufactured colour 'shadow' is a transparent shade, so that when it is applied over another colour the base colour shines through.

cadmium yellow midnight green sunlit green country olive

Tip

Cadmium yellow can be an opaque colour: if it is mixed thick enough, it can be added over a dark background without the need for masking fluid.

The reason that I only use one yellow is because I have three ready-mixed greens, which eliminates the need for a whole variety of yellows. Midnight green is a dark bluey-green, perfect for painting on the shaded parts of trees but also can be diluted to a pale bluey-green for distant trees; sunlit green is a yellow-green, good for highlighting foliage and also for fresh, sunlit passages of a landscape. The final green is country olive, a middle range green, which can form the overall 'summer' colour, but is also useful for mixing with other colours to give the whole range of greens without the fear of the paints turning muddy.

Useful mixes

This is a simple guide to mixing some colours that are used for painting a selection of popular flowers.

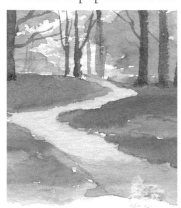

cobalt blue *permanent rose* *bluebell mix*

Bluebells

Bluebells are surprisingly difficult to paint, mostly because the colours of bluebell woods appear to vary quite a bit due to changing light conditions. A simple mix that you can use for bluebells is cobalt blue and permanent rose. You can substitute alizarin crimson for the permanent rose for a variation.

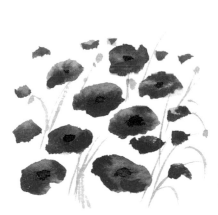

cadmium red (weak mix) *cadmium red (strong mix)* *two-tone effect*

Poppies

In contrast to bluebells, poppies are simple to paint! The main colour I use is cadmium red, which can be used neat for a strong, bright red, or watered down to give the appearance of sunlight shining through the petals for a two-tone effect. The centre of the poppies is simply added with a dot of shadow.

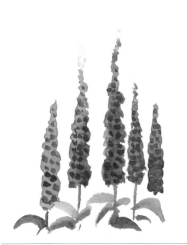

permanent rose
(lighter tint)

permanent magenta
(darker shade)

shade added wet-into-wet

Foxgloves

These flowers look their best with a dark background, so it is best to mask the area where you want them beforehand. The contrast emphasises their unusual shape and brings out the brightness of the colours. The base colour for foxgloves is permanent rose, and I use permanent magenta for the darker shades. You can vary this darker shade by using alizarin crimson.

A note on my palette

The watercolour palette I use has a clip-on lid. When the palette is not in use, it keeps the tube colours from drying out. The benefit of this is that when you want to start painting again, you can simply open the lid and the paints are still workable. The other advantage is that when you finish painting, you can clip the lid back on to protect the colours while you rinse the rest of the palette clean.

Cool colours

Colours are split into two groups, warm colours and cool colours. Cool colours such as cobalt blue and midnight green are associated with winter or spring scenes, so spring paintings often use a cooler palette than summer ones.

A good example of cool colours; this painting of a spring scene uses a selection of cool blues for a misty background and still waters. This has a calming effect, and using the bluebells as the focal point enhances the springtime feel.

I have used some warm colours in the foreground flowers. This contrasts with the bluebell colour and emphasises the coolness of the background. Notice how the yellow flowers have a large impact on the painting. This is because warm colours tend to come to the fore of a painting and be immmediately noticeable, while cool colours recede. This is also why things in the background tend to be bluer than things close up.

Compare this painting with the similar scene on the facing page, and notice that although I have used many of the same colours, the ones that I have changed give a completely different feel to each of the paintings.

Bluebell Glade
330 x 500mm (13 x 19½in)

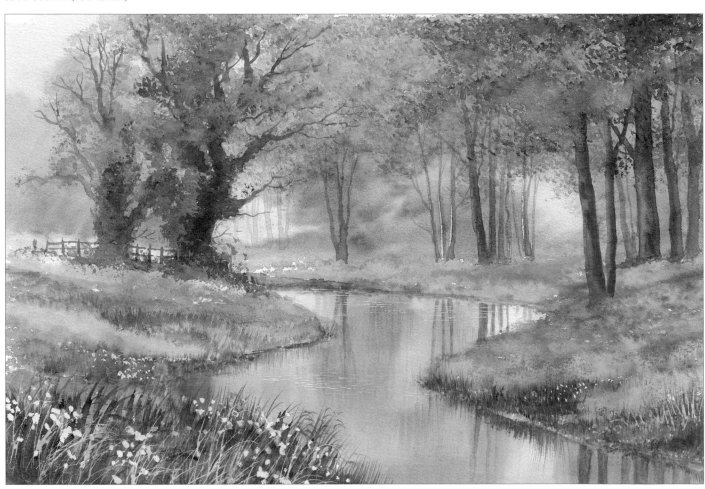

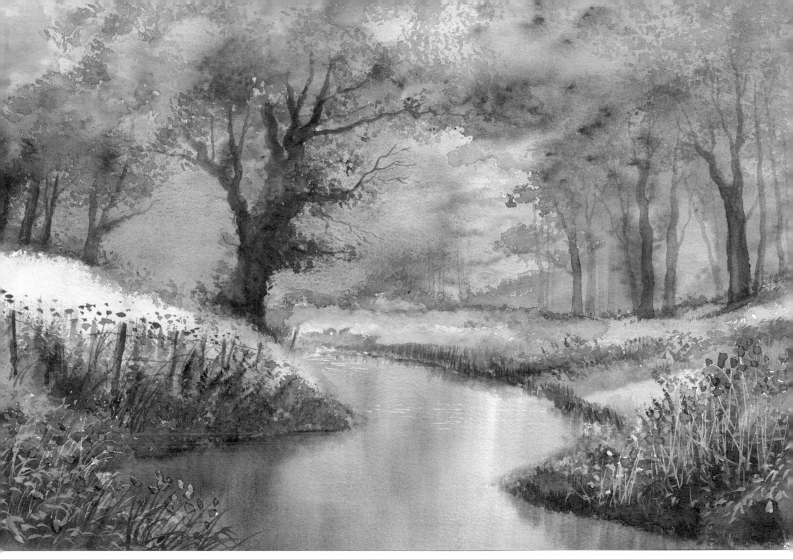

Summertime
330 x 500mm (13 x 19½in)

Warm colours

Warm colours such as cadmium red, cadmium yellow and sunlit green are more associated with summer scenes or sunnier climes, so using a warm palette will enhance the effect of such a painting. Earth colours such as burnt sienna and burnt umber are warm colours: the word 'burnt' is the giveaway!

This painting has a very similar composition to *Bluebell Glade*. The background colours were painted wet-into-wet using mainly the warm colours sunlit green, country olive and cadmium yellow, but also a little cool cobalt blue to enhance the feeling of recession at the back of the painting. These colours are also reflected in the water.

As the painting comes forward, I have used raw sienna and a mixture of burnt umber and burnt sienna to build up the warm summer shades on the water's edge. This is highlighted by splashes of red that prevent the warm browns from dominating the painting and making it dull. This is a good example of how flowers can immediately enhance and lift a painting.

Similarly to its companion piece opposite, *Summertime* has flowers at the front of the painting; but this time I have used cool colours on this warm scene. The cool colours at the top and bottom of the painting act as a frame for the warm focal point at the centre.

Using photographs

This section explains how you can use a selection of photographs to produce one masterpiece. The finished painting is a typical watermill with a chalk stream, and is fairly faithful to the actual scene. However, I have combined several views of the same scene to create the final picture.

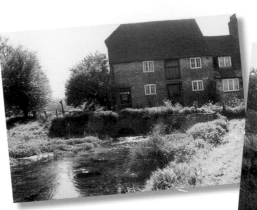

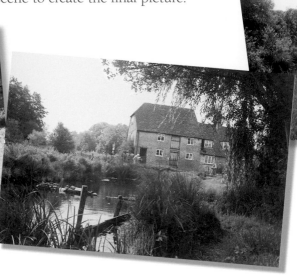

The third photograph shows the detail in the foreground, including the gate.

This first photograph shows the detail of the mill, including where the mill stream runs through the arched outlet from the mill wheel.

The second photograph has the mill in the middle distance, giving the painting depth, and ensuring that although the mill is the focal point of the painting, it is not the dominant feature.

One of the big problems with using photographs is if you copy them too faithfully, you can end up with a dull finished picture. For example, the third photograph shows the gate perfectly, but the mill itself is obscured by a mass of trees, and is also in the shade. The first photograph shows the mill more clearly but the foreground is uninspiring.

Although each photograph could be used as a painting in its own right, by selecting the best elements of each, and with a little artistic licence, you can create a more successful painting. For example, the photograph showing the gate is fine, but by having the gate slightly opened rather than as a barrier, the viewer is drawn into the painting.

Every time I hear a professional artist using the expression 'I only use photographs as an *aide-mémoire*', I know as well as you know that they copy and combine them to create a convincing painting. In short, don't feel that you are cheating by using photographs, but if you are asked, be sure to tell people that you only use them as an '*aide-mémoire*'!

Opposite
The Watermill
350 x 500mm (13¾ x 19½in)
This painting was made by combining various photographs of the same scene with a little artistic licence. The important part of this painting is adding the variety of different flowers in the foreground, bringing colour and interest to the overall picture.

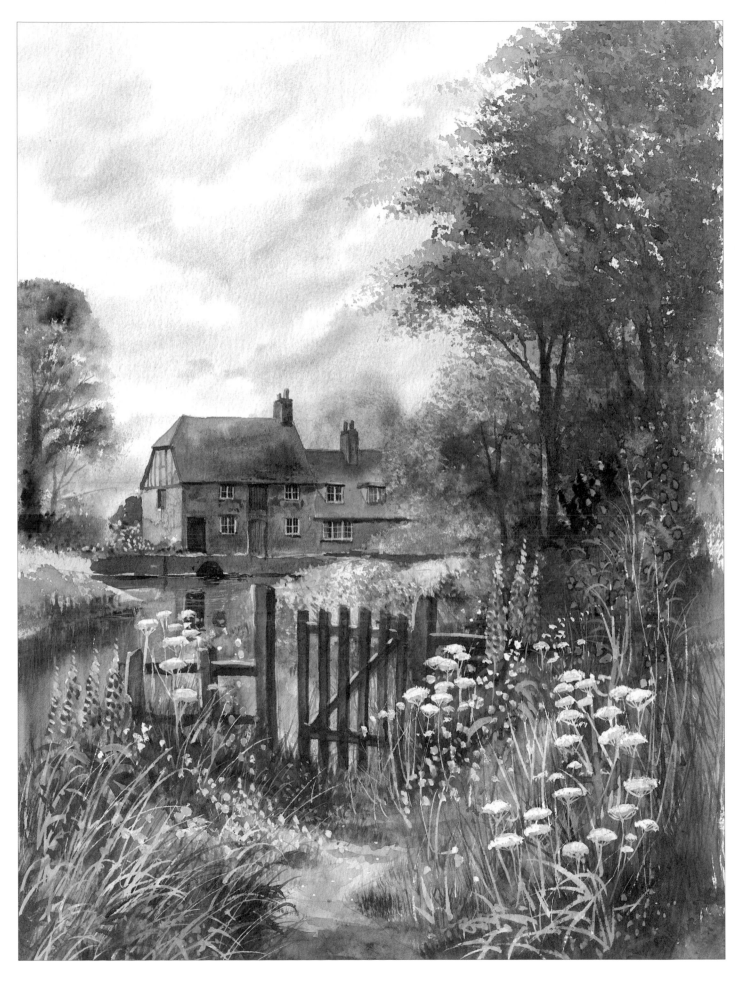

Techniques

Using the brushes

Different brushes create different effects. Here is a variety of different brushes that will give you a whole selection of brush strokes.

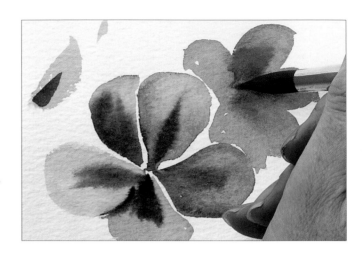

Large detail

The large detail brush can hold a large amount of paint, but still tapers to a fine point. This makes it perfect for larger leaves and petals.

Medium detail

When you need more control, for instance when painting broad but long leaves or plant stems, the medium detail brush is ideal.

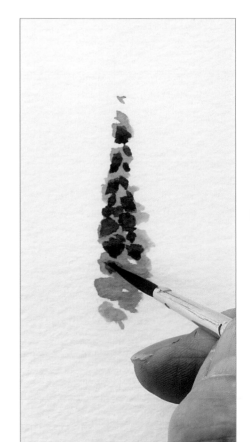

Small detail

The small detail brush, as its name suggests, is used for the very finest details – including adding shading to flowerheads, as shown.

Half-rigger

Very long, fine grasses and stems are easy to paint with this brush. The hair is long and goes to a very fine point, but it still holds a lot of paint.

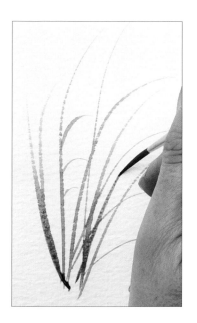

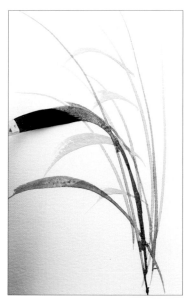

Sword

The sword holds a lot of paint, and the angled head tapers to a blade. This makes painting stems and grasses very simple, and produces results similar to traditional Chinese brush painting.

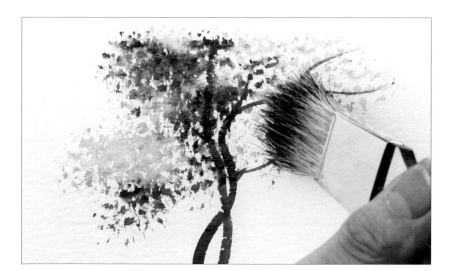

Golden leaf

The golden leaf is great for laying in washes. The hard bristles of the brush are mixed with softer hair that curls when wet, so when used with dryer mixes, you can get fantastic texture with this brush – perfect for underlying foliage or leaves.

Foliage

Essentially, the foliage brush is a smaller version of the golden leaf brush. It is ideal for foliage, as its name suggests; but it is also fantastic for painting carpets of bluebells.

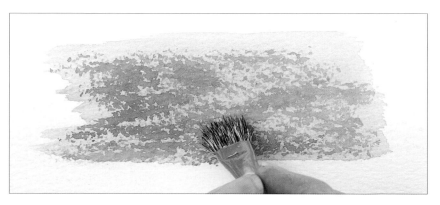

Wizard

As well as being useful for laying in small washes, the two different lengths of hair on this brush give a slightly ragged effect that is ideal for grasses.

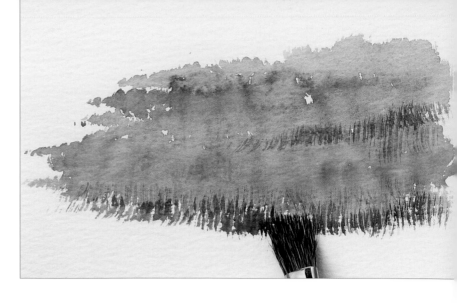

Fan stippler

The fan stippler makes painting trees easy, since the fanned end is the curved shape of treetop foliage.

Fan gogh

By flicking a lightly-loaded fan gogh upwards, you can easily paint grasses, and by turning the brush on its side so that it points vertically, you can paint ferns by touching the brush to the paper and pulling sideways.

Fan gogh px

This brush has the same head as the fan gogh, but the perspex handle is angled and perfect for scraping out grasses and the veins of leaves.

Other techniques

Double-loading
You can paint in ready-shaded foliage with the fan gogh brush. Simply load one side of the brush with light green, and the other with dark green (angle the brush into the paint to avoid mixing them). Then simply dab the brush on to the paper for ready-shaded trees.

Quick poppies
Block in the petals with the large detail brush and a thin wash of cadmium red, then add a slightly stronger shade of the same mix for shading. Working wet-into-wet, use the colour shadow to drop in the centre of the poppy. Finally, press the centre of the poppy firmly with your finger (see inset) and remove to reveal a quick, perfect poppy.

Scraping out rocks
The texture of rough watercolour paper makes it simple to paint realistic rocks quickly, using a plastic card to scrape them out.

1. Block in the shape of the rocks using the wizard and a variety of greens and yellows. These colours should be applied fairly dry.

2. Cover the rocks with a wash of ultramarine; again, not too wet.

3. Place the plastic card on the paper and, with a sharp tug downwards, scrape the paint off the paper. Repeat for the rest of the rocks.

Masking fluid unmasked

Masking fluid is a water-resistant latex that is used to mask detail on watercolour paper and preserve the white of the paper from the watercolour paint. When the paint is dry, the masking fluid can be removed by rubbing it with your finger, revealing clean paper underneath. Paint can then be added to these areas, ensuring the colour is clean and fresh.

Masking fluid can be applied with a variety of techniques. This demonstration will unravel the mysteries of masking fluid.

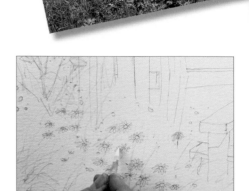

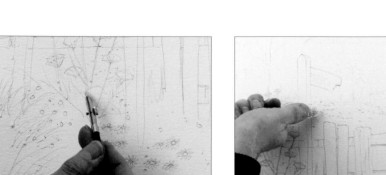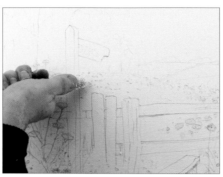

1. Draw the scene with an HB pencil, then mask the stems of the flowers and some of the grasses in the foreground using the ruling pen.

2. Dip a toothbrush into the masking fluid and draw your thumb over the bristles to spatter masking fluid over the cornfield area. Spattering is uncontrollable, so do not overload the toothbrush.

3. Using the masking fluid brush, mask the flowerheads. It is important to draw the daisies in detail first before attempting to paint the petals.

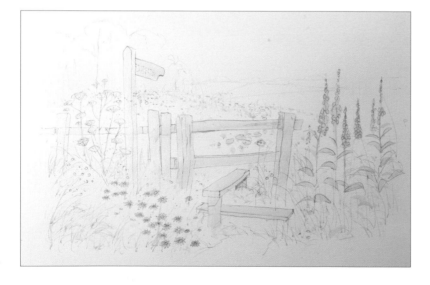

Tip

When using a brush to apply masking fluid, wipe the head over a bar of soap first. The soap acts as a barrier between the bristles and the masking fluid, so you won't damage your brush. It also ensures that the masking fluid is easily rinsed off with clean water afterwards.

4. Still using the masking fluid brush, mask the foxgloves, leaves, fence and signpost in the foreground, and the poppies in the middle distance.

5. Allow all the masking fluid to dry, then use the golden leaf brush to wet the sky with clean water, then add an ultramarine wash wet-into-wet. Leave spaces for the clouds, and paint these with a thin wash of raw sienna.

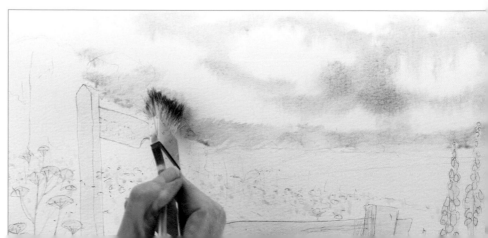

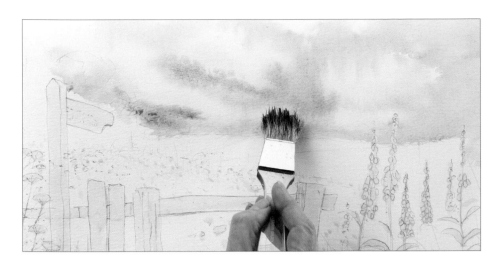

6. Add shading to the bottom of the clouds with a thin mix of ultramarine and burnt umber.

7. Touch in the distant hills on the horizon with the small detail brush, using a mix of ultramarine and midnight green.

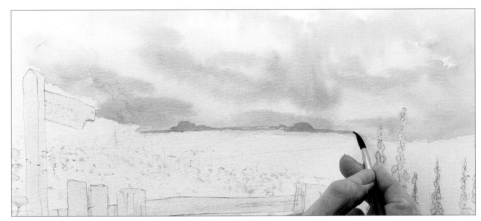

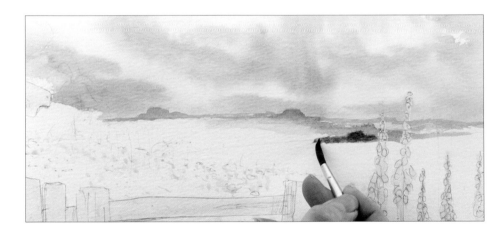

8. Paint in the hedgerows in the distance using a stronger mix of the same colours.

9. Using various mixes of raw sienna, sunlit green and burnt sienna, paint in the distant fields.

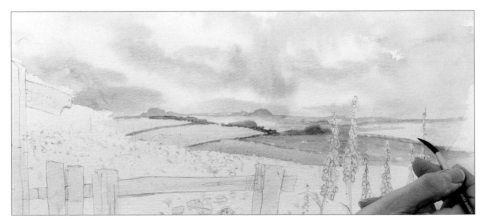
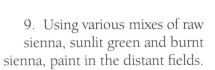

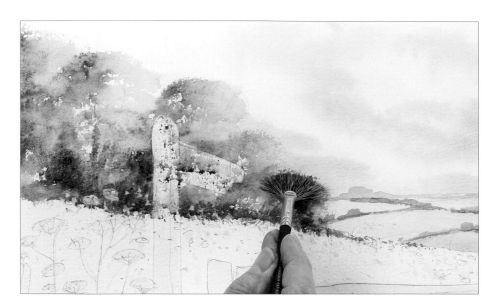

10. Double-load (see page 17) the fan gogh with sunlit green and a mix of midnight green and country olive. Paint in the trees on the top left. Keep the mix fairly strong as this area will provide a dark background for the signpost later.

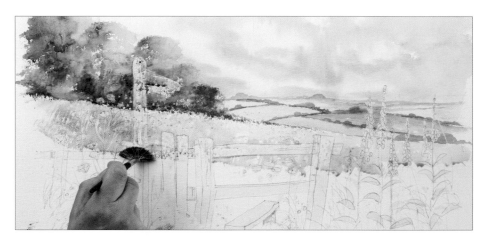

11. Paint the cornfield using the fan gogh brush and raw sienna. Introduce burnt sienna to the colour on the left to vary the tone.

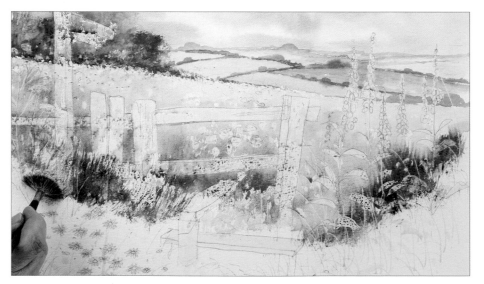

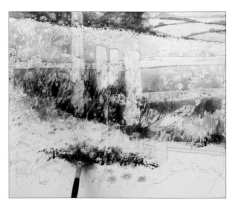

12. Returning to the fan stippler, block in the grass with a mix of raw sienna and country olive. Vary the tones by adding a little midnight green.

13. Use burnt sienna for the dead grasses, then add a thin wash of sunlit green underneath. Frame this with a strip of midnight green.

14. Repeat this dark green, light green, dark green pattern on the right-hand side of the painting.

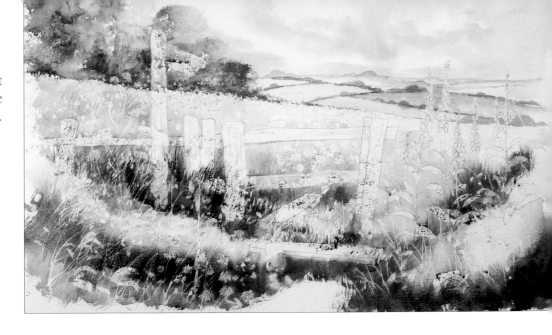

15. Paint in the footpath with a fairly strong mix of raw sienna.

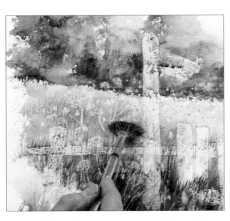

16. Allow the painting to dry, then darken the cornfield behind the cow parsley with the fan gogh and a mix of raw sienna and burnt sienna.

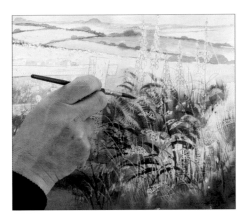

17. Use midnight green to add texture to the grass, then switch to the half-rigger and paint in dark stems and grasses on the right.

Tip
When painting grasses or trees, paint in the direction the plant grows. This is generally from bottom to top, but branches may grow sideways, or even downwards. The important thing is that you start at the base.

18. Make sure the masking fluid is dry and remove it by rubbing it with your fingers. Switch to the large detail brush. Paint in the fence and stile with a raw sienna/sunlit green mix. Add burnt umber for the parts in the shade. Allow to dry, and add detail with a mix of burnt umber and country olive.

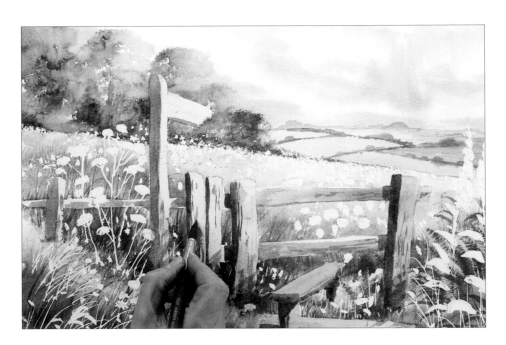

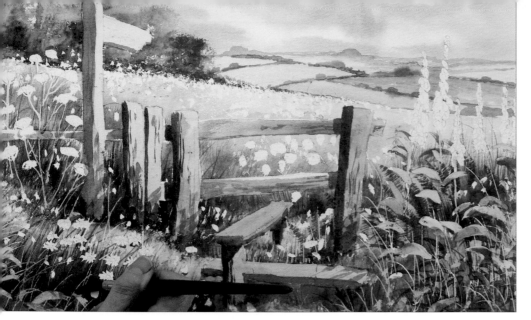

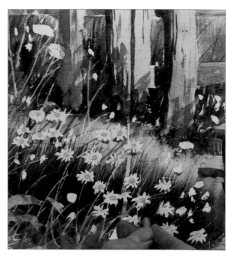

19. Gently wash over the foreground stems and leaves with a combination of the three greens and a sunlit green/raw sienna mix. Be careful not to wash over the flowerheads.

20. Use the half-rigger to tidy up the petals of the daisies, then dab a spot of cadmium yellow into each centre. Tidy up the daisies with pure white gouache.

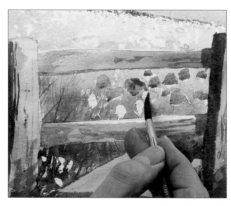

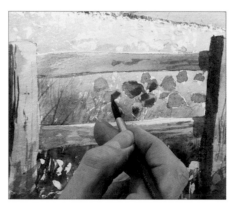

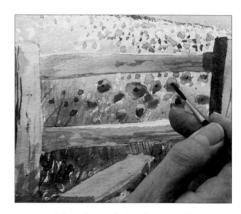

21. Using the medium detail brush and a thin mix of cadmium red, paint the poppies.

22. Dab a stronger mix in wet-into-wet to give a two-tone effect.

23. Add a dot of shadow with the half-rigger to finish off the poppies.

24. Returning to the medium detail brush, use a mix of permanent rose and permanent mauve to paint in the foxgloves. Work wet-into-wet with a stronger mix to show the shaded insides of the foxgloves. Add a touch of sunlit green at the top of each flowerhead.

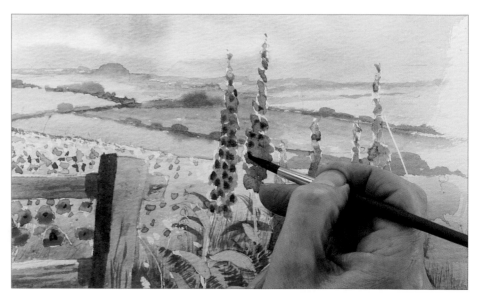

25. Shade the cow parsley with a thin mix of cobalt blue and a touch of raw sienna.

The finished painting
380 x 560mm (14¾ x 21¾in)
I have added a few details such as some additional shading on the fence and some small yellow flowers with cadmium yellow in amongst the foreground grasses.

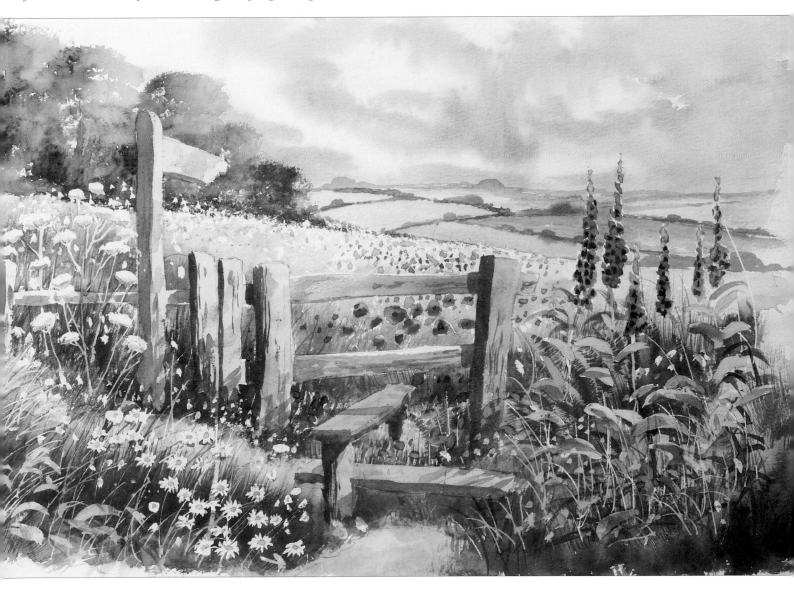

Rose Doorway

This could be a typical mediterranean courtyard, with roses around the doorway and potted plants in the foreground, all bathed in dappled sunlight.

The photographs that I have used were gathered over a period of time. The main photograph with the blue shutters would make an interesting painting, but it lacks colour. By adding the pink roses at the top of the picture and the additional pots in the foreground, the scene is made to look more idyllic.

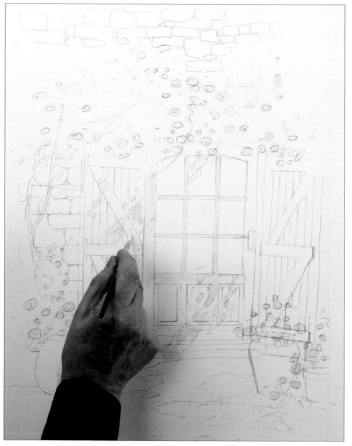

1. Mask out the flowers on the vine and in the pots, the window frames and the dappled sunlight on the door and shutter.

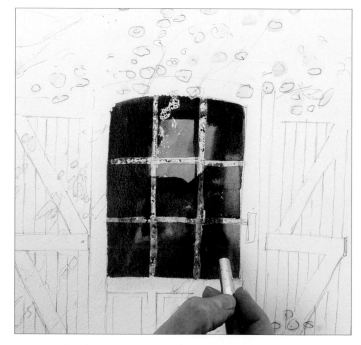

2. Use the large detail brush to lay in a dark wash of ultramarine, burnt umber and a touch of midnight green on the window of the door.

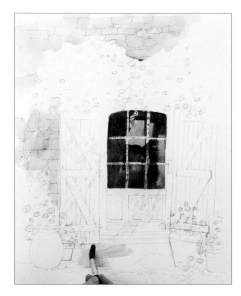

3. Continue using the large detail brush to wash in the wall using raw sienna tinged with a spot of permanent rose to warm it slightly. Use a lighter wash for the ground.

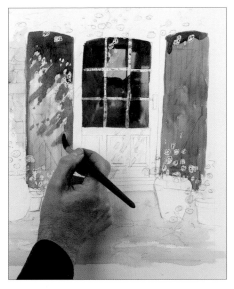

4. Paint the doors with a mix of cobalt blue and permanent rose with a touch of shadow. The key to this colour is keeping it fresh. Use a stronger wash for the door on the right, and detail the left-hand door with this darker colour.

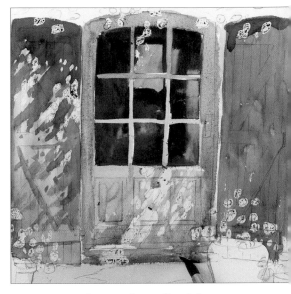

5. Remove the masking fluid from the window frame. Wash a raw sienna and cobalt blue mix on to the door and window frame. Deepen the shadows around the door by adding more cobalt blue.

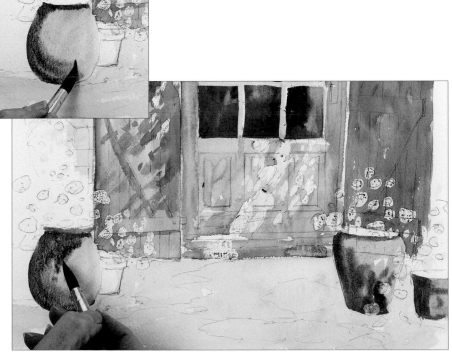

6. Paint the pots with a thin wash of burnt sienna, then add shadow wet-into-wet to shade. Finally, use a stronger mix of burnt sienna for texture.

7. Use the golden leaf brush to stipple the background foliage in sunlit green.

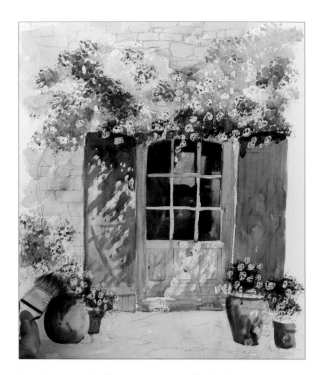

8. Use midnight green to add darker tones to the foliage.

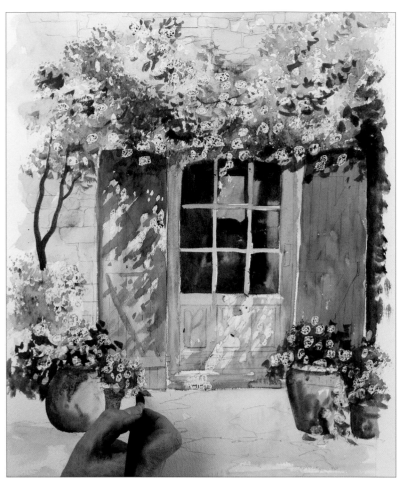

9. Define the foliage with the large detail brush using midnight green and country olive. Add the vine on the left using a mix of burnt umber and midnight green.

10. Remove masking fluid from the door and shutter.

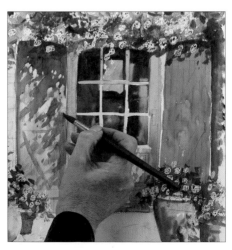

11. Lay in a very thin cobalt blue wash on the shutters with the medium detail brush.

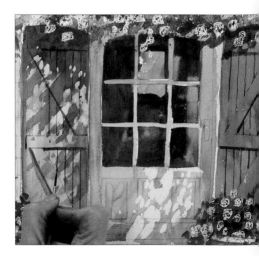

12. Use the half-rigger with a shadow and ultramarine mix to add fine details to the shutters.

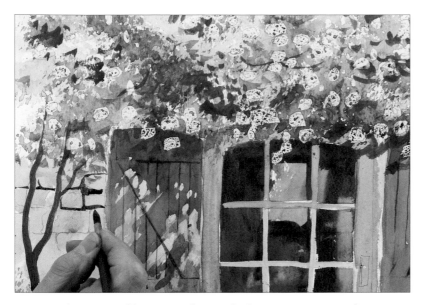

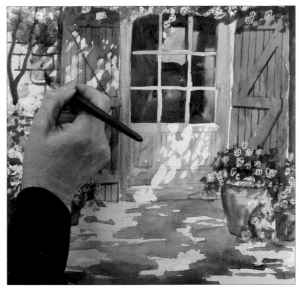

13. Apply a mix of burnt umber and ultramarine using the medium detail brush to suggest detailing on the brickwork.

14. With the large detail brush, shade the dappled ground with a mix of shadow and cobalt blue. The dark colour at the bottom of the page anchors the painting and stops the eye drifting out of the picture. Use the same mix to shade behind the shutter.

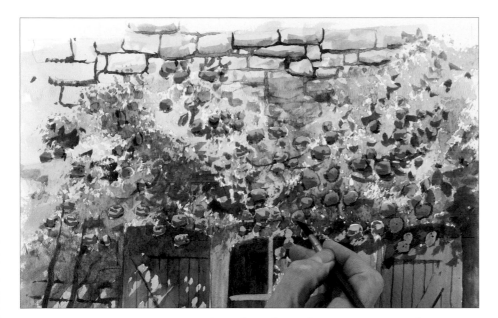

15. Remove the remaining masking fluid from the painting. Use the medium detail brush to apply a thin wash of permanent rose to the blooms above the doorway, then add a stronger mix wet-into-wet to add detail.

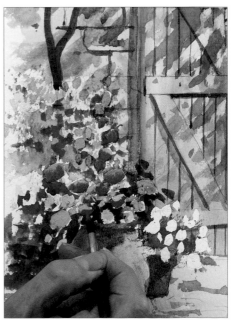

16. Dilute cadmium red and paint the roses in the pot, at bottom left. Drop in a darker tint wet-into-wet.

17. Using permanent mauve, paint the begonias in the next pot with a dilute wash. Dot a darker mix in the centre of each flower.

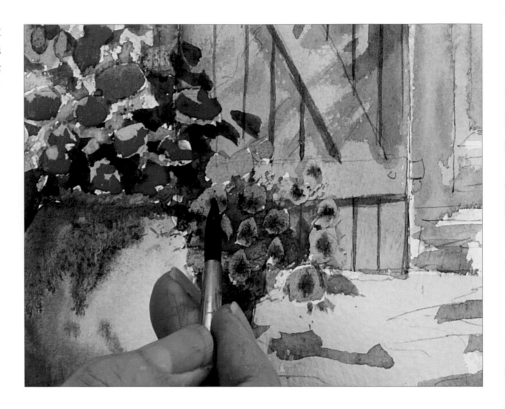

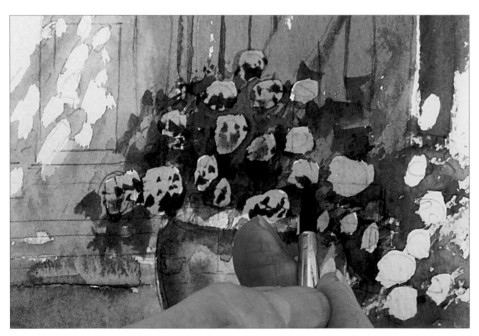

18. Use permanent rose to paint the flowers on the bottom right. Allow this area to dry and then stipple a mix of permanent rose and permanent mauve on to it to add texture.

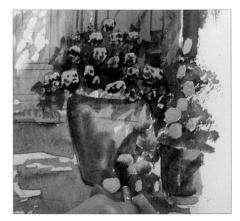

19. Use a cadmium red and cadmium yellow mix for the flowers in the final pot. Add more red to vary the tone and add texture.

Opposite
The finished painting
560 x 380mm (21¾ x 14¾in)
Standing back, I decided the final painting needed some additional detailing, such as the door handle, which was added using shadow.

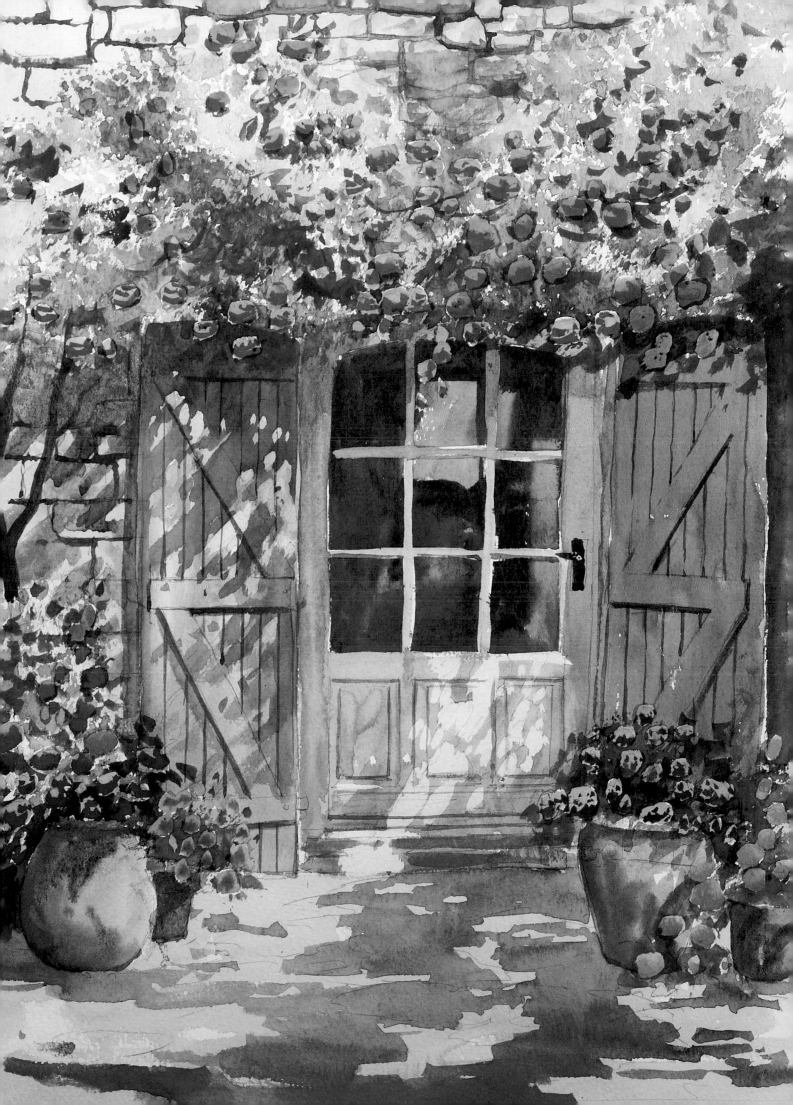

Floral Stream

I used two photographs as inspiration for this painting. The photograph of the stream provided the basis for the painting, with the large tree on the left of the scene. I decided that the original photograph was too enclosed, so I pruned the tree back to reveal the rolling hills in the distance. This is a good example of how to enhance your pictures with a little artistic licence.

1. Draw the scene, and use masking fluid to mask the daisies in the foreground, and the other flowers bordering the riverbank on both sides.

2. Block in the sky with clean water using the golden leaf brush, and then paint the spaces between the clouds with ultramarine. Paint the clouds with a dilute mix of raw sienna, and shade them with a mix of burnt umber and ultramarine.

3. Use the medium detail brush to paint the hedgerows in the distance with a mix of ultramarine and midnight green. Increase the amount of midnight green in the mix for the closer hedgerows.

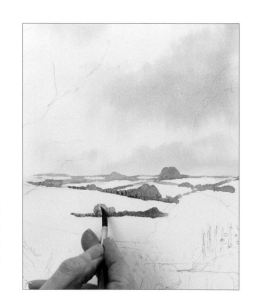

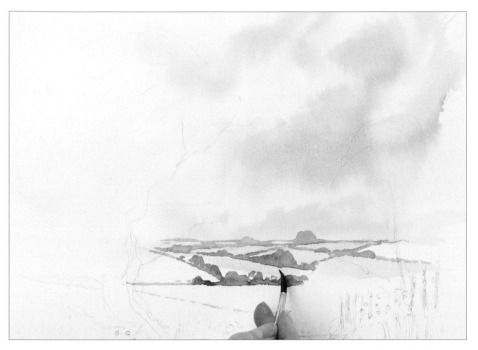

1. Lay in the closest hedgerows with a mix of sunlit green and midnight green. When dry, use ultramarine and midnight green to paint the most distant field. Add country olive to the mix as you paint the nearer fields, and add raw sienna for the very nearest.

5. Use raw sienna to paint the fields in the middle distance. Do not use too strong a mix: it will act as a barrier to the eye. Continue building up the fields into the foreground.

6. Paint in the trunk of the tree on the left using the large detail brush and a mix of burnt umber and country olive.

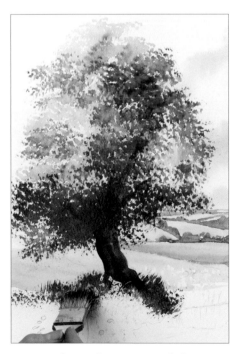

7. Stipple sunlit green and then country olive with the golden leaf brush to form the mass of leaves. Use burnt umber and midnight green for the shaded grass at the base of the tree.

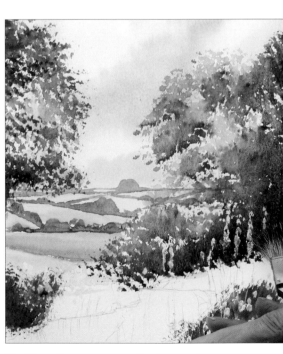

8. Use the same method to paint the tree and foliage on the right.

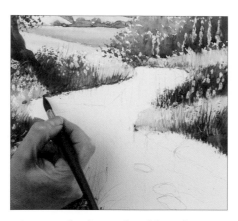

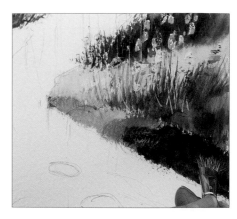

9. Add alternating bands of yellow ochre/sunlit green and midnight green/burnt umber down the painting using the fan gogh. Ensure the dark bands frame the majority of the flowers.

10. Use the large detail brush to paint a mix of burnt sienna with country olive on to the edges of the riverbanks. Use the same colour to add rushes and dead grasses.

11. Paint the rocks on the riverbank using fairly dry mixes of raw sienna for the most distant, then sunlit green for the middle rocks, then burnt umber for the nearest.

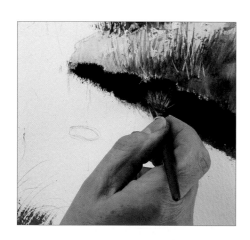

12. Using the wizard brush, paint ultramarine over all the rocks on the riverbank. Again, use fairly dry mixes.

13. Scrape out the rocks following the instructions on page 17. Repeat from step 11 for the rocks in the stream.

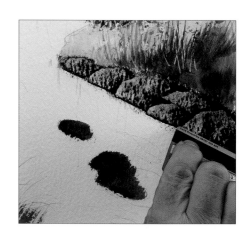

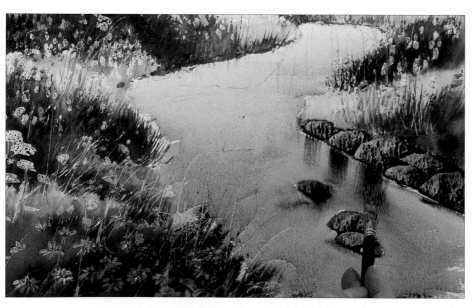

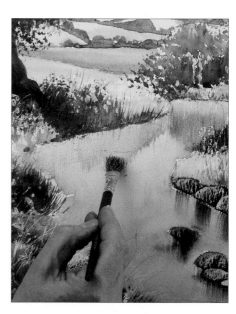

14. Paint the stream with an ultramarine wash, using a stronger mix as the stream gets closer. Use the wizard to pull paint from the bottom of the rocks into the river to form the reflections.

15. Using the wizard brush, paint reflections wet-into-wet, ensuring the same colours are used in the reflections as in the object.

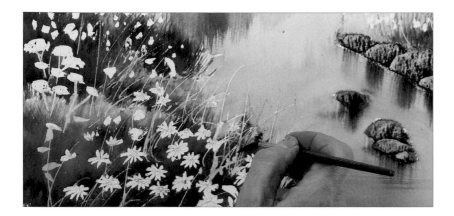

16. Remove all of the masking fluid from the painting. Paint in all the stems using a sunlit green and raw sienna mix with the medium detail brush.

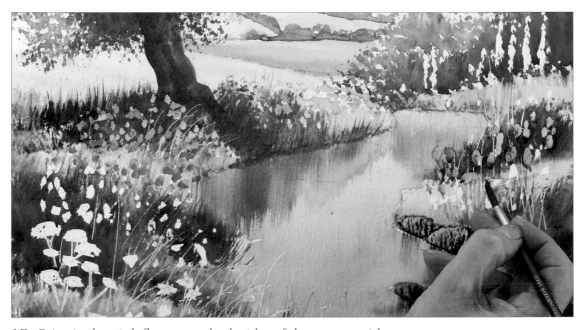

17. Paint in the pink flowers on both sides of the stream with permanent rose. Use a stronger mix on those closer to you.

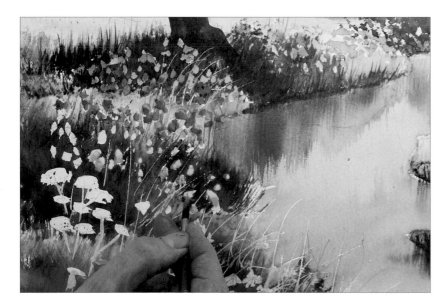

18. Use a strong mix of cadmium yellow to paint the yellow flowers, and add a touch of cadmium red to the mix to shade.

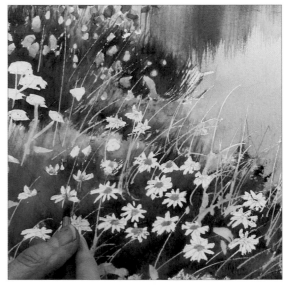

19. Use this same orange mix to paint the centres of the daisies.

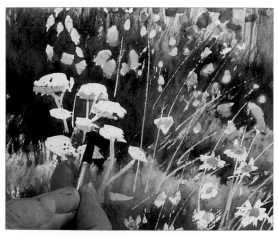

20. Shade the cow parsley with a weak mix of cobalt blue and raw sienna.

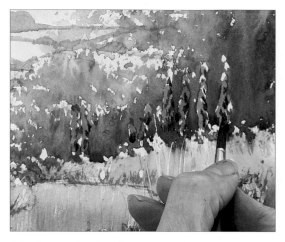

21. Paint the foxgloves using a permanent rose and permanent mauve mix. Detail when dry with a stronger mix of the same colour.

22. Using the half-rigger and midnight green, paint in some tall grasses amongst the daisies.

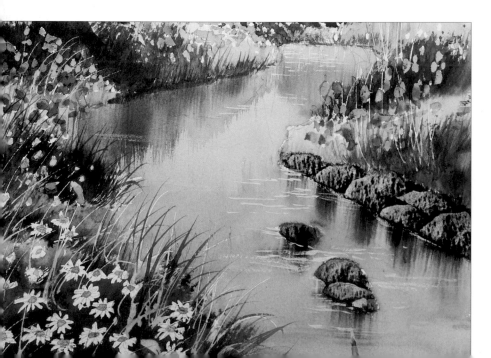

23. Using the small detail brush and permanent white gouache with a touch of cobalt blue, add fine ripples to texture the stream.

Opposite
The finished painting
380 x 560mm (14¾ x 21¾in)
With the splashes of colour provided by the summer flowers, this scene becomes much more interesting and appealing.

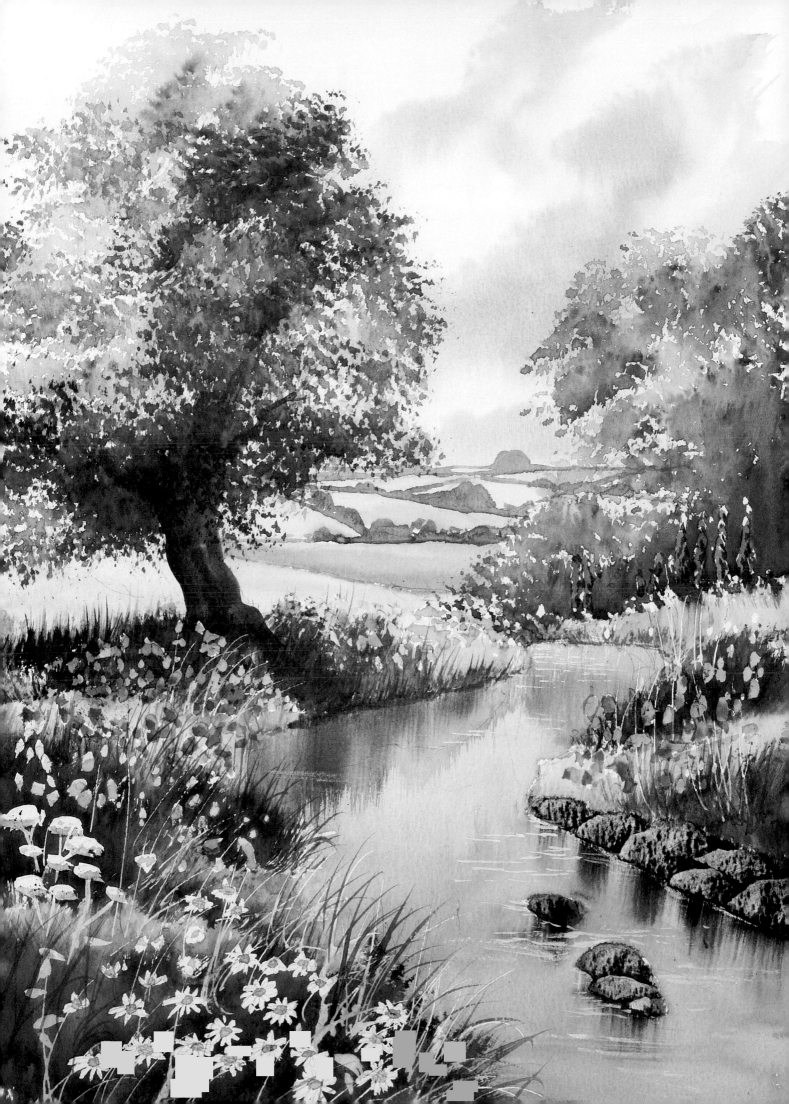

Farm Poppies

The addition of poppies quickly transformed this landscape into a more interesting and appealing painting. The farmhouse forms the backdrop to the painting, with the fence running horizontally across the centre of the picture. This could form a barrier across the composition, but the poppies lead the viewer's eye into the scene.

I mainly used warm colours to evoke the feeling of summer, and the bright, appealing poppies only enhance this feeling.

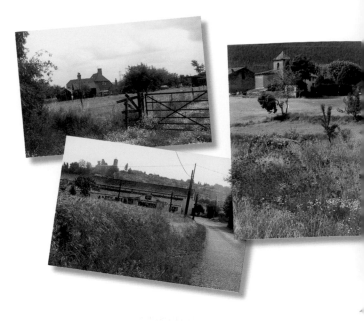

1. Mask the flowers and fence with the masking fluid brush. Use the ruling pen for the longer grasses.

2. Wet the sky area with clean water. This is best done with the board at a slight angle. Using the golden leaf brush, dab ultramarine into the damp area, leaving spaces for clouds.

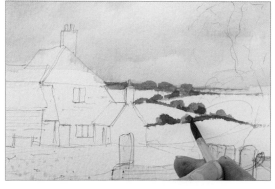

3. With the medium detail brush and a mix of ultramarine and midnight green, paint the distant trees and hedgerows. Add more midnight green to darken the mix for the closer hedgerows.

4. Lay country olive into the most distant fields, sunlit green into the field in the middle and raw sienna into the nearest.

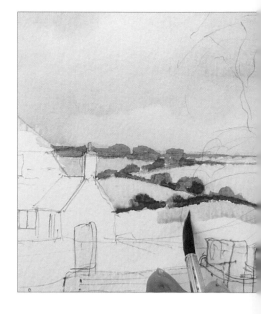

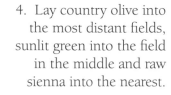

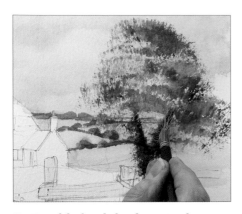

5. Double-load the fan stippler with midnight green and country olive, and work down the tree from top to bottom. Stipple vertically with midnight green to represent ivy on the trunk.

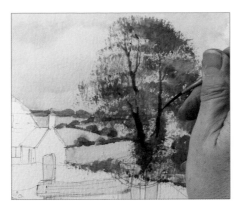

6. Add in the trunk and branches with the half-rigger brush and midnight green. Add the hedgerow using a mix of country olive and sunlit green.

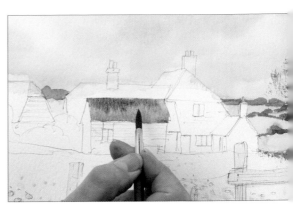

7. With the medium detail brush, paint the trees between the buildings with the ultramarine/midnight green mix. Paint in the central roof with a burnt sienna, raw sienna and shadow mix; add a stronger mix of the same colours wet-into-wet to vary the tone.

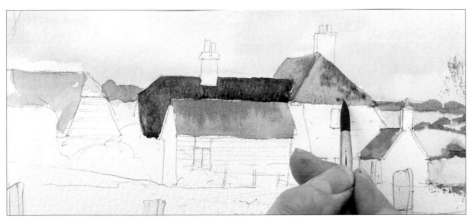

8. With the medium detail brush, paint the other roofs and house using a mix of burnt sienna and raw sienna. Add more burnt sienna for the darker roof. Add texture by adding a little midnight green and shadow to the mixes. Use raw sienna with burnt sienna dropped in for the gable as shown.

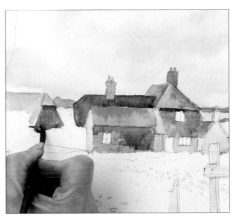

9. Use a mix of raw sienna and country olive for the barns. Vary the tones of each section wet-into-wet before moving on to the next.

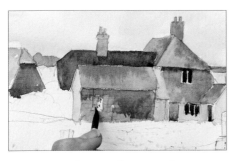

10. Paint the windows and door in with a burnt umber and ultramarine mix.

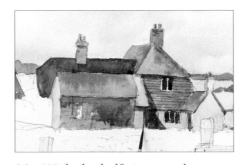

11. With the half-rigger and shadow, add detail to suggest brickwork and hung tiles. Paint the shadows cast by the buildings.

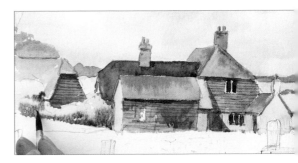

12. Using the medium detail brush and sunlit green, add in the foliage around the farm buildings. Add shading with midnight green wet-into-wet. Let the darker shades bleed into the lighter parts.

13. Use the large detail brush with a mix of burnt umber and country olive to paint the tree on the left.

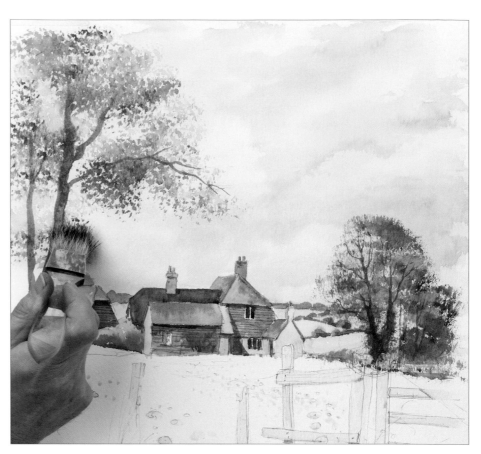

14. Use the golden leaf brush to stipple in foliage using sunlit green. Add shading with midnight green.

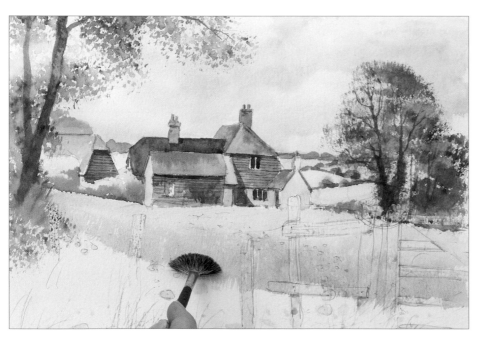

15. With the fan gogh, block in the cornfield with a wash of raw sienna. With a stronger mix of the same colour, add the closest rows of corn.

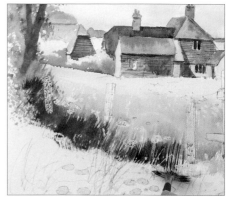

16. Still with the fan gogh, work wet-into-wet and flick country olive up to form grass that softens the edge of the field. Add a layer of midnight green over the top of this to add texture and shade.

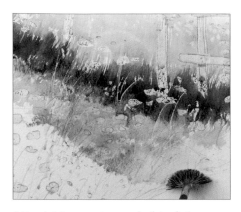

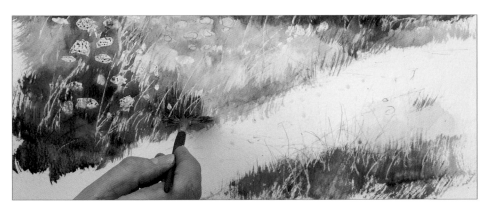

17. Add raw sienna behind the poppyheads to form a 'hot spot' of warm colours. Add sunlit green underneath this area near the path.

18. Continue the strip of sunlit green on the right-hand side of the path, then add midnight green areas under the poppies and the light green strip. This will frame the poppies.

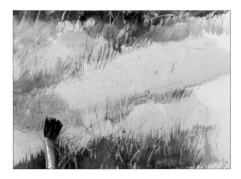

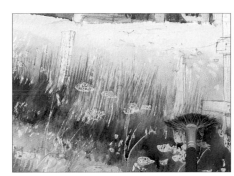

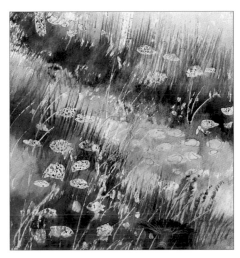

19. Use the wizard to paint in the path with raw sienna, and texture and shade it by adding burnt umber.

20. Add standing corn by flicking a mix of raw sienna and burnt sienna upwards with the fan gogh.

21. Use the same technique with midnight green to add foreground grasses.

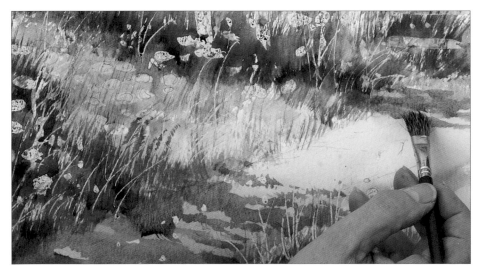

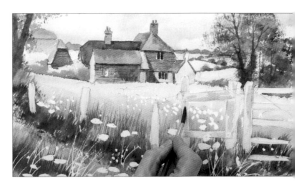

22. Add shadow to the main path with the wizard, then allow it to dry and rub off all the masking fluid.

23. Paint the fence with raw sienna and sunlit green, using the medium detail brush.

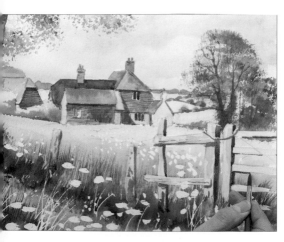

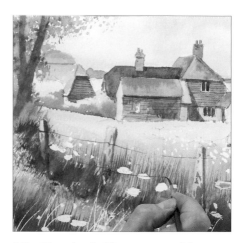

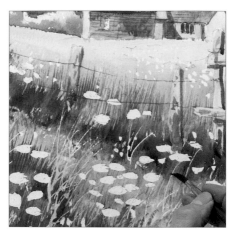

24. Shade the fence with a mix of burnt umber and country olive.

25. Use the half-rigger to add in the wire, with burnt umber toned down with a little country olive.

26. With the medium detail brush, block in the poppy stems with a mix of country olive and sunlit green.

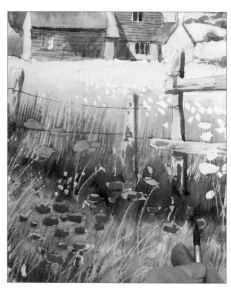

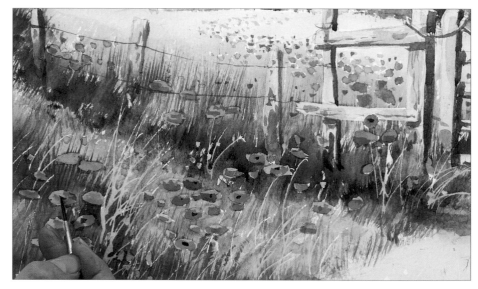

27. Paint the poppies in with a weak mix of cadmium red, and add detail with a stronger mix.

28. Use shadow wet-into-wet to put dots in the centres of some of the poppies. Not all the flowerheads will be facing you, so do not paint the centres of all the poppies as this will look strange.

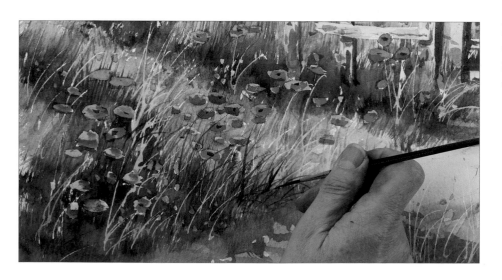

29. Paint the yellow flowers with cadmium yellow, then use the half-rigger and midnight green to flick in extra grasses for interest.

Opposite
The finished painting
380 x 560mm (14¾ x 21¾in)
This is a good example of how to use flowers in a landscape to create a beautiful country scene.

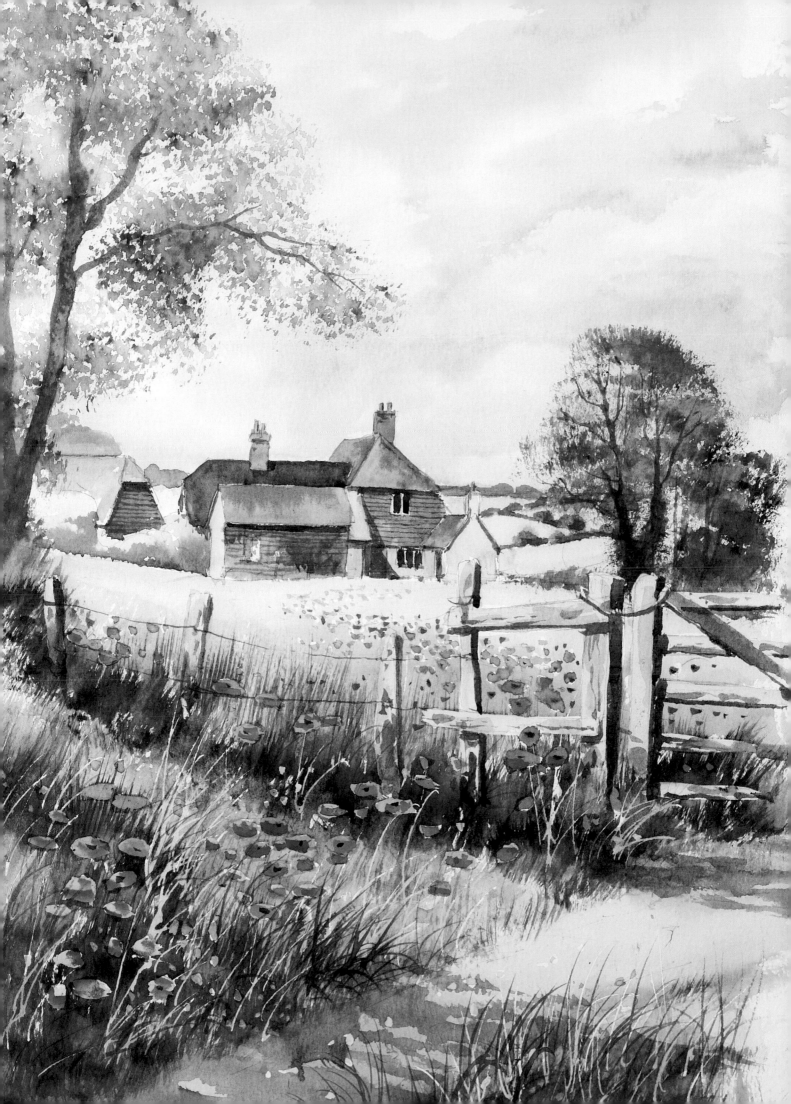

Bluebell Wood

Who can resist a bluebell wood? Certainly not me! This demonstration is created in a fairly loose style; I have not put in too much detail. Using a combination of photographs, I have created a fairly simple scene with a footpath leading to the centre of the painting through the drifts of bluebells, and framed by simple trees.

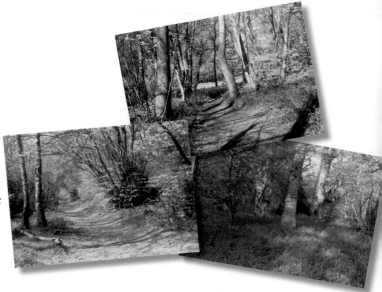

1. Mask out the silver birch trees on the left and the grasses at the bottom. Dot in the flowerheads.

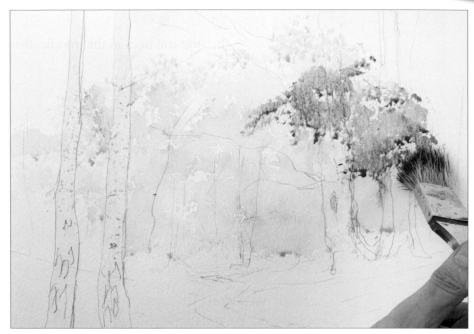

2. Using the golden leaf brush, and working wet-into-wet, stipple cobalt blue into the centre of the painting, then surround this with cadmium yellow, and finally surround this with sunlit green.

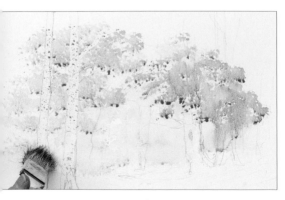

3. As you work outwards, start using stronger mixes of the same colours.

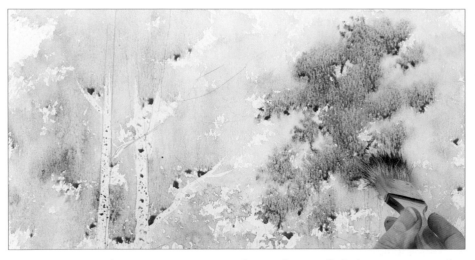

4. Continue working wet-into-wet, and introduce still-darker mixes into the work. Allow to dry.

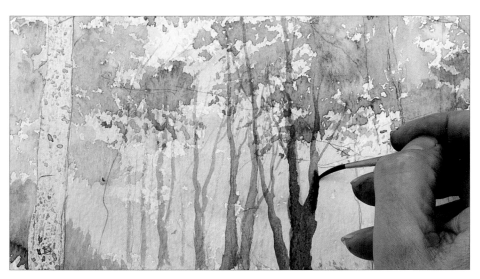

5. Using the half-rigger and cobalt blue with a touch of sunlit green, paint faint tree trunks into the misty central area.

6. Add the trees in the middle distance using a mix of cobalt blue with country olive.

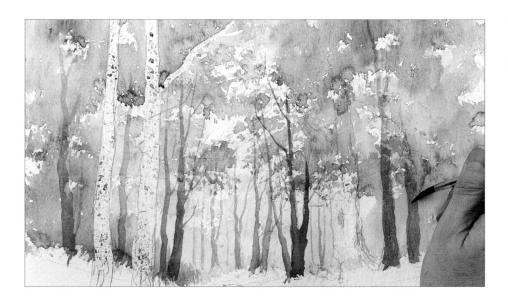

7. Paint the near-distance trees with the medium detail brush and a mix of country olive and burnt umber.

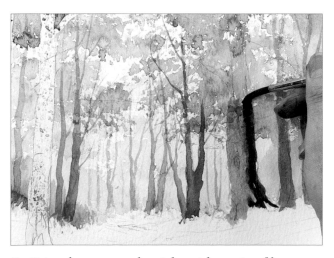

9. Use the wizard to paint the path with raw sienna. Start with a weak mix in the distance, becoming stronger as you reach the foreground.

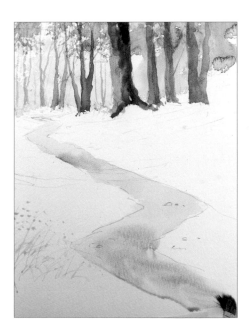

8. Paint the tree on the right with a mix of burnt umber and country olive. Add details with a stronger mix.

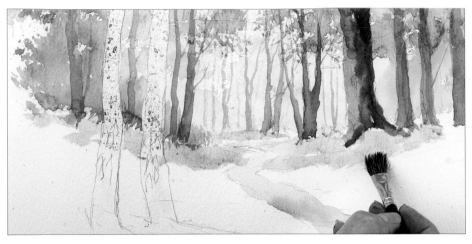

Tip
A clean palette is a must to get the necessary translucency for the bluebells. Rinse off the palette before mixing the bluebell colour.

10. Use a mix of cobalt blue and permanent rose to add a soft wash of bluebells with the wizard.

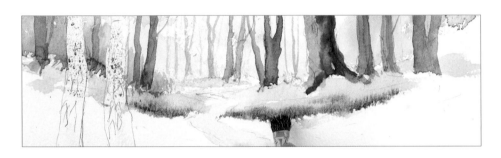

11. With a stronger mix of the same colours, add a darker swathe of bluebells; then a further line of the lighter shade.

12. Add strips of grass below the bluebells using a pale mix of midnight green.

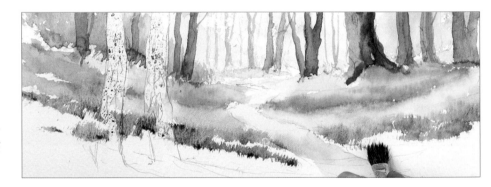

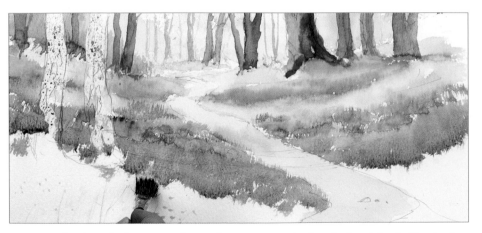

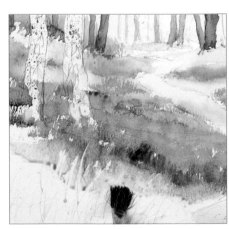

13. Pat the brush downwards on the paper with the darker bluebell mix for further bluebells underneath the grassy strip.

14. Working wet-into-wet, blend sunlit green into this bluebell strip.

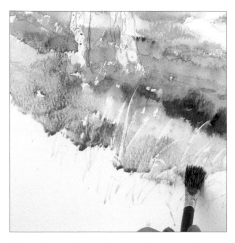

15. Extend the forest floor with raw sienna.

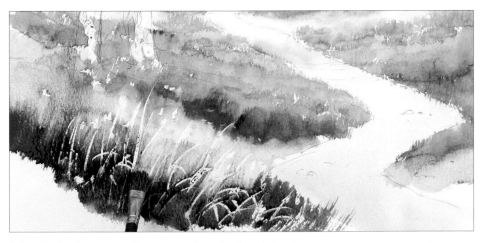

16. At the bottom of the painting, flick midnight green wet-into-wet into the forest floor and extend it to the edge of the paper.

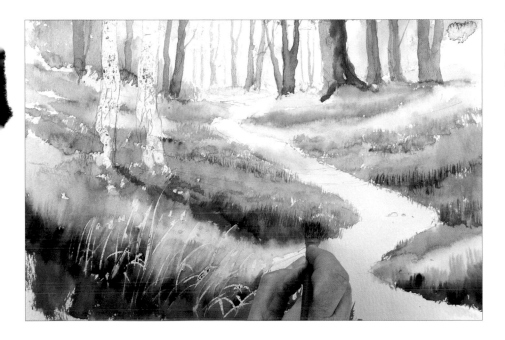

17. When dry, use midnight green to texture the grassy areas. Use the wizard with short downward strokes.

18. Load the fan gogh with midnight green and add detail to the foreground grassy area with an upwards flicking motion.

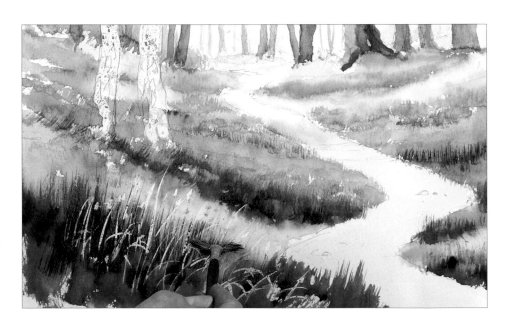

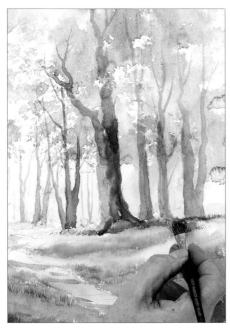

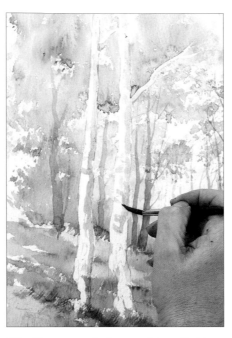

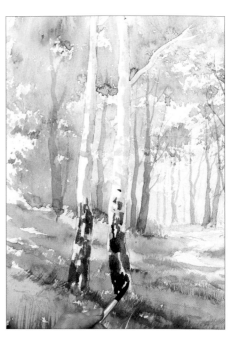

19. With the wizard, add a fairly weak mix of shadow across the path and under the trees.

20. Remove all the masking fluid, and shade the silver birches with a mix of cobalt blue and raw sienna. Use the medium detail brush.

21. Paint the split bark at the bases of the trees with an ultramarine and burnt umber mix.

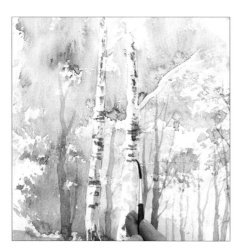

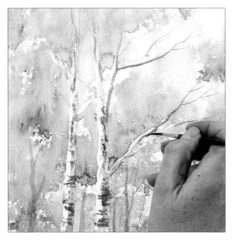

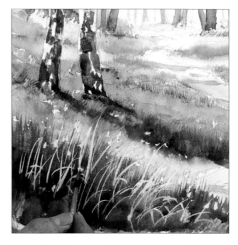

22. With the same mix, use the half-rigger to paint horizontal strokes across the tops of the trees.

23. Still using the same mix and half-rigger, hint at branches at the tops of the silver birches.

24. Wash over the grasses with a pale mix of sunlit green and the medium detail brush. Paint the flowers with cadmium yellow.

25. Using midnight green and the golden leaf brush, stipple foliage on to the silver birches wet on dry.

Opposite
The finished painting
380 x 560mm (14¾ x 21¾in)
I hope that after seeing how easy it is to create a bluebell wood, you will not be able to resist painting one either!

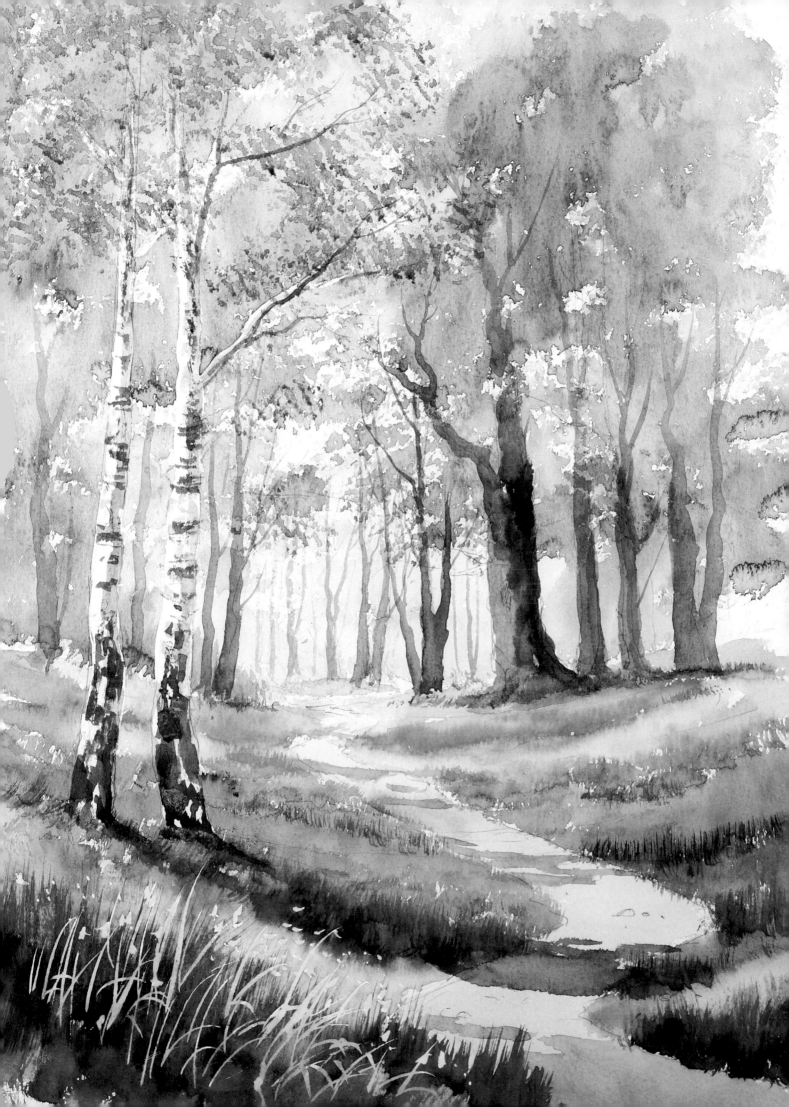

Index

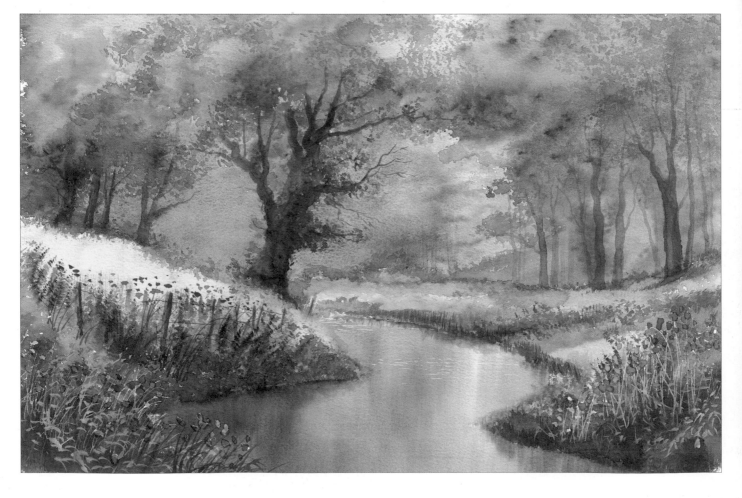